THIS
WORKBOOK
BELONGS TO:

NAME

DRAW YOURSELF!

Dedicated to those who
DON'T KNOW WHERE to START,
Jane who has a SYSTEM for
EVERYTHING, and
FRED who keeps me on track.

ISBN: 978-1-4521-5556-2

Manufactured in China.

Illustration by Mary Kate McDevitt
Design by Ryan Hayes

10 9 8 7 6 5 4 3 2 1

Chronicle books and gifts are available at special quantity discounts to
corporations, professional associations, literacy programs, and other
organizations. For details and discount information, please contact our
premiums department at corporatesales@chroniclebooks.com or at
1-800-759-0190.

Chronicle Books LLC
680 Second Street
San Francisco, CA 94107

www.chroniclebooks.com

ILLUSTRATION WORKSHOP

FIND YOUR STYLE, PRACTICE DRAWING SKILLS, and BUILD a STELLAR PORTFOLIO

Mary Kate McDevitt

CHRONICLE BOOKS

SAN FRANCISCO

TABLE OF CONTENTS

36 ASSIGNMENTS

158 PRACTICE SHEETS

180 CHALLENGES

INTRODUCTION

There is something so rewarding about getting to be creative every day. Illustration has provided that creative outlet for me, and it can do the same for you. But in order to reap those benefits, you need to learn a set of skills. Figuring out what to draw, finding your style, and staying on track with projects are challenges every illustrator faces. Whether you are already taking on client work, just beginning to think about a career in illustration, or even if you just love to draw and fantasize about making your own greeting card line, this workbook is for you. In these pages, you'll find illustration assignments and creativity-boosting drawing exercises to help you find your voice as an illustrator, hone your technique, and develop a consistent personal style.

My path to illustration as a career started out with a passion for art. Growing up, I always had art supplies handy, but it wasn't until my senior year of high school that I decided I was going to pursue art. At Tyler School of Art in Philadelphia, Pennsylvania, I took a variety of classes from sculpture and fiber to painting and drawing, but when I started taking design classes, I quickly realized that would be my focus. I soon discovered that when I began incorporating hand lettering into my work, I felt more connected to my projects, and creating work was more effortless.

Later, after graduating in 2007, I started working at a small design studio. I was working on projects I wouldn't have chosen for myself, where my skills as an illustrator weren't being utilized. I felt thankful to have this design job but knew I wasn't heading down the right path, so I did what I knew best and started to make art again. I opened an Etsy shop and started selling my paintings, along with chalkboards featuring inspirational messages in my hand lettering, which I called "Mini Goals Chalkboards." Soon I was contacted by Chronicle Books to publish my chalkboards as a notepad—and it was that project that inspired me to set out on my own as a freelance illustrator. So, I moved across the country to Portland, Oregon, and set up shop with my boyfriend (also cat), Peppy Mew Mew, and a few other artists in a cute studio called Magnetic North.

It was at that point that my illustration work for clients really started taking off. I started out with editorial projects, mostly for small, local papers, but those jobs soon led to more and more work, such as designing and illustrating book covers, creating hand-

lettered headlines for advertisements for Smucker's and Nintendo, and creating editorial illustrations for national magazines, such as *O, The Oprah Magazine* and *Fast Company*. Setting out on my own led me to a career doing what I love.

Taking that leap really challenged me to try new things and always keep drawing. I quickly learned that I had to organize a process to help keep my work focused and ever-improving, which in turn leads to more illustration opportunities. Even now that I am nearly ten years into my freelance career, I look to personal assignments to push my work further and keep my portfolio diverse.

The assignments and exercises in this workbook are meant to help you in the same way. I've adapted my own process for creating illustrations into this workbook to help you learn by repetition and hone your drawing skills. So you always have a new project to turn to, there are twelve illustration assignments inside, each with step-by-step guidance and all structured like real projects from an art director. Included along with the assignments are warm-ups to loosen you up before starting a drawing, practice pages for building your drawing skills, and challenges to break up your usual approach to drawing. No matter your mood or skill level, there are pages in this workbook to satisfy your drawing needs. If you're feeling determined, get started on an assignment. If you aren't in the mindset to be creative, try one of the warm-ups. If you're feeling underwhelmed by the work you've been making, take on one of the challenges. This workbook will help you build up confidence and develop a portfolio that best showcases your talent, all at the same time.

ILLUSTRATING *like an illustrator*

WHAT IS ILLUSTRATION?

Illustration is a fancy name for commercial art. What's the difference between illustration and drawing? Simply put, illustrators are hired to create art for commercial use. Both drawing and illustration can be commissioned and have a concept and personal style, but when a drawing is created for a commercial context—such as a book, magazine, advertising, product packaging, or branding—it's an illustration.

Determining the kind of illustrator you want to be and pursuing the kind of work you want is a process. If you're just starting out, try seeking out editorial illustration jobs for local papers and magazines; mail a postcard of your work with your contact information to clients you'd like to work with. If you are more interested in licensing and product illustration, open an online shop and start making products featuring your illustrations. You can also find local art fairs where you can sell prints and products of your work. The assignments in these pages will help you determine what kind of illustration suits you and create a portfolio that fits the kind of projects you are passionate about.

FINDING YOUR STYLE

Having a distinct style is how illustrators get hired by art directors. But it doesn't always come naturally. One way to find your style is by gathering inspiration, from all areas of art and design. Study a wide variety of artists and look for a common thread—there may be line qualities, color palettes, motifs, or materials that you are consistently drawn to. It's best to look to a wide variety of illustrators and artists to keep your influences varied and diverse. Study how they use line, color, and texture, and experiment with your own methods of image-making to find what feels right for you. Once you have a more defined vision for your style, you will approach projects with more confidence. But don't feel too confined to one method; branching out of your comfort zone will help keep your ideas fresh.

COMBINING CONCEPT WITH STYLE

Illustration involves thinking both like an artist and a problem solver. This workbook will ask you to consider questions like: How will my illustration work best when being used on a greeting card? What will a bottle of soda look like in my style? Considering the context of your illustration, and creating a concept that addresses it, elevates your work to something that is marketable.

A strong concept is important and can make an otherwise "OK" illustration excellent, but a strong concept will go unnoticed without a compelling image. Illustrations are most successful when style and concept work together.

CONSIDERING YOUR TARGET AUDIENCE

When working with a client for an assignment, often the client has done a huge amount of research leading up to hiring an illustrator. Generally, you've been hired because your style or concept skills best match their goals, but be sure to familiarize yourself with the client and who the audience is that they are aiming to reach. It's also important to define the target audience for your personal assignments in this workbook. Consider how the style of an illustration affects and appeals to different audiences. For example, if you have a playful illustration style, perhaps your work primarily appeals to families or children. But let's say a project is targeted squarely to adults. How might you adjust your style or concept to better reach that audience? Sometimes something as simple as adjusting your color palette can help reach a new audience. It's important to have flexibility in your style so you don't corner yourself in a small market.

ILLUSTRATING like an illustrator

RESEARCHING YOUR CONCEPT

The first step to illustrating is doing research. If you're brainstorming and the page is empty, that may be a sign you need to do more research for inspiration that will hopefully trigger new ideas. This stage is also important for understanding what already exists, what has worked, and what will work for you. As you research, look for inspiration and images that relate to your assignment that can inspire your choice of style, color, and concept. You want a collection of images that is diverse. This will help you avoid focusing on one image for inspiration, and it will also help you develop a unique concept and style. With a broad view of the project, your brainstorming will be more fruitful and lead to more unique concepts.

Take note of your references and sources by keeping them organized in a file or online. It's important to be knowledgeable about who and where your sources of research come from, not only so you can reference them later, but to be more informed and aware about the world of illustration. No one creates great illustrations in a bubble. I use Pinterest to organize most of my research.

TAKING DIRECTION

Illustration is often a collaborative effort and involves balancing another's ideas with your own. The key to a successful collaboration is to be open to ideas and engage in conversation about the direction of the concept and illustration. If you find your ideas are either getting shut down or changed, be accommodating, but you may also need to sell your idea and explain why you believe that direction would be best.

CRITIQUING YOUR WORK

Whether you are sending an illustration to a client or creating personal work, look at your work with a critical eye. As a practice, start showing your work to a trusted friend for a fresh pair of eyes. Soon, you'll be able to identify and make more critical changes on your own. If you don't have someone to look over your work, try stepping away from the illustration, and revisiting your illustration inspiration after a day or two. Then return to your illustration with a fresh perspective.

WORKING BY HAND OR USING THE COMPUTER

Working digitally can be an excellent creative tool. But starting on the computer may make it easier to skip some crucial steps in illustrating. To avoid jumping into one idea before sketching out others, I like to do my sketching in a sketchbook. You take more time when you draw, which in turn allows for more refinements to composition and scale before going to final. That said, it's becoming rarer to find illustrators who don't use the computer at all. I personally do all the sketching by hand, but all the inking and color digitally. I try to do entire pieces by hand from time to time, typically in my sketchbook or personal projects. Experiment with different combinations of hand rendering and digital work to find what's right for you.

SELF PROMOTION

Once you get through this workbook, you'll have a whole new portfolio of work waiting to be shared with someone besides your cat. Creating a website, if you don't already have one, or sharing your work through social media platforms, such as Instagram, Facebook, and Twitter, are great ways to present your work professionally as an illustrator. I also find Pinterest to be a great place to share your work and images that inspire you. So, replace some of those selfies with some #WIP (work in progress) and #finalpieces, and you'll start building a following. Remember that you are your best advocate!

MATERIALS

Visiting the art supply store can be a daunting adventure. This list is pared down to the essentials, but pick and choose what you feel works best for you. Remember to test pens and pencils at the store before you purchase (that's what those notepads by the pen displays are for!), or ask the shopkeeper for their advice.

MICRON

GEL PEN

ROLL PEN

PENS

Use pens for line work in your illustrations. If you have more detailed and delicate line work, use a fine-tip pen. If you want to create a bolder and more graphic illustration, a bolder pen would be more appropriate. Be sure to wait for the ink to dry before using markers, colored pens, or colored pencils to add color.

PENCILS

Nº2

MECHANICAL

Pencils can add beautiful, subtle, textured lines in finished artwork. There are basically two kinds of pencil lead: H is harder and B is softer. For sketching, H pencils are best, but for darker textures, B pencils work well. You can also start with color, using markers or colored pencils, and then work on top of the color with pencil. Be sure to use a slightly softer lead, such as a 2B pencil; the typical No. 2 pencil might not show up on some colors.

Eraser

Always have an extra eraser handy. Also, you may want to sketch lightly because lightly drawn pencil is much easier to erase.

Whoops!

COLORED PENCILS

Colored pencils are easy to work with to create texture and bold color. Start by lightly applying light and neutral colors, then work up to bolder colors. The harder you press the bolder the color gets, so be certain you have the color assigned just how you want before you dive in too hard.

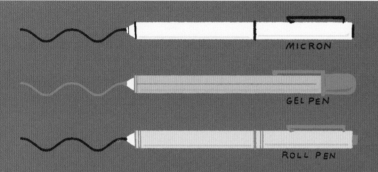

RULER

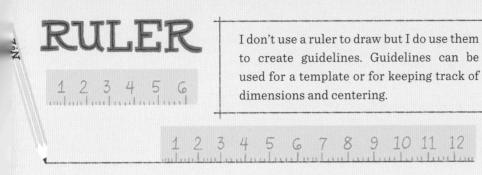

I don't use a ruler to draw but I do use them to create guidelines. Guidelines can be used for a template or for keeping track of dimensions and centering.

MARKERS

Brush Tip

Chisel Tip

Bullet Tip

With a little practice, markers can be a great solution for creating even color. When you're layering colors, start with the lighter colors and work your way to the darker colors. Be sure to let the ink dry between layers. Keep in mind that some markers work best on thicker paper, so be sure to test them in this workbook.

Extra PAPER

Don't limit your ideas by how much blank paper you have to work on! Also, for some projects in this book, you may want to try working at a large scale; you can use this workbook to create a rough sketch and then work larger on your extra paper. You may also find that you want to create more sketches or thumbnails than the space provided in this workbook allows.

Tracing Paper

Plain Paper

Tracing paper is great for making several iterations of one drawing to make more subtle revisions without having to go through a ton of erasers. However, tracing paper tends to smudge easily.

Plain paper isn't as transparent but can still be placed on top of a drawing to trace.

SCANNER

For scanning your drawings! You can also use your phone when you want to take a photo of a sketch for reference, but scanners have better quality.

GRAPHICS TABLET

A graphics tablet can be used to create drawings digitally with a stylus pen using a graphics application like Photoshop. It simulates drawing with a pen and paper, but helps streamline the process by eliminating scanning and also allows you to undo and make edits quickly. It's a costly investment but can be a big timesaver!

ILLUSTRATION 101:
overview of the process

Let's take a look at the process of creating an illustration from start to finish. In the assignments in this workbook, this process is outlined and organized for you to tackle step-by-step, from brainstorming to the final illustration. To better help track your progress and improve your illustration skills, you will be redrawing each sketch from thumbnail to final; but outside the workbook you can use extra paper, trace, or work on top of existing sketches, if you like.

PROJECT BRIEF

A brief from a client or art director defines the goals of the project, so you have a reference to consult as you work—do so early and often. The brief will also often include dimensions, background information, such as the target audience, and sometimes images of your work that the client responded to when deciding to hire you. In this workbook, the brief is outlined at the beginning of each assignment. When you work with a client, it's important to review the brief closely, forecast potential hurdles, think about your process moving forward, and educate the client on how you work. Making sure that you and the client share the same vision—via a project brief—will make the rest of the process go smoothly.

BRAINSTORM

The first thing to do when you are starting a project is to get your ideas flowing by approaching it from every angle, keeping in mind the goals set out in the brief. Brainstorming includes the lists, mind maps, research, inspiration, and exploration that help narrow the focus of your project. Be sure to consider your audience as well. Try starting by writing lists of words or making a mind map of concepts that you associate with the assignment, or even try doodling some of those key words. This is also the time to collect inspiration based on the brief to help visualize how this project will look.

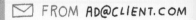

✉ FROM AD@CLIENT.COM

HELLO!
WE HAVE an ASSIGNMENT WE BELIEVE YOU'D BE PERFECT FOR.
YOU WOULD CREATE a SPOT ILLUSTRATION FOR AN ARTICLE ABOUT WINNING WITH GRACE.

DIMENSIONS are 5"x 7"

IT WOULD BE GREAT TO SEE SKETCHES NEXT WEEK

BEST,
AD
CLIENT.COM
@CLIENT

LISTS

MEDAL	HORN	HUMILITY
RIBBON	BANNER	PROUD
TROPHY	WINNER	HONOR
TROPHY CASE	FINISH LINE	GRACE
PODIUM	RACE	HUMBLE
LAURELS	TRACK	SPORTSMANSHIP
GOLD		

MIND MAP

When you're at this exploratory stage, be sure to push yourself. For example, if you were brainstorming for an editorial piece on summer reading and only focused on the first few words that come to mind—let's say you thought of *sun*, *pool*, *book*—then the illustration would be pretty basic. But after more research—maybe you flipped through some travel magazines or looked at vacation spots online—you might be able to expand your scope into different and more distinctive directions: *pool tiles*, *kites*, *sunglasses*. So, try to list and sketch as many ideas as you can, and then select the ones that you think best align with the goals outlined in the brief.

THUMBNAILS

Thumbnails are small sketches that lay out the basic composition of the illustration and visually express the concept. This is the stage when you start putting your ideas together and laying the groundwork for your illustration. Refer to the brief for dimensions, as well as your brainstorming. Detail is not important at this stage; you just want to create compositions to refer to when you begin your sketches. Start loose and be sure to consider positive and negative space, along with concept, hierarchy, and composition, and work in proportion to the dimensions.

SKETCHES

Sketches are more detailed versions of the thumbnails but still remain loose and rough. Choose thumbnails that reflect your favorite concepts and layouts to take to sketches. Make sure you have the right dimensions, and focus on layout and composition, rather than the details—you'll fix those at the next stage.

Extra paper can be handy as you take your thumbnail and reinterpret it at a larger size. If you are working outside this workbook, or if you want to try out a few different options before drawing in this workbook, you can use extra paper to rough out the thumbnail sketches to the appropriate scale.

Then, use those drawings as a reference for the sketches you create in this workbook. Make adjustments, guidelines, and notes as you work at this stage. And remember to sketch very lightly, because it can be tricky (nay, impossible) to erase pencil lines that are pressed into the paper.

Seek out any opportunities to strengthen your composition. For example, change of scale can create more dynamic compositions than when everything is at the same scale. Try to look out for awkward tangents and spaces, and always remember to check spelling! Make notes of errors and things you need to adjust for the revised sketch. The sketch at this stage will be a little rough, with sketchy pencil lines, eraser marks, and notes—you'll fix that at the next step.

REVISED SKETCHES

A revised sketch is just redrawing your sketch so that it's fresh and new. It allows you to see a close approximation of the final but still make revisions before everything is finalized. There are a few ways of creating a revised sketch. You can redraw your previous sketch, considering the notes and areas that need attention as you go, or you can trace your previous sketch while making revisions.

When working with an art director, presenting a rough sketch will make it difficult for the client to approve the sketch and move to final. A clean, revised sketch that closely resembles your final style, however, is easy to imagine in color and makes the approval process more straightforward. Keep these sketches in pencil, however, so you can still make any final adjustments easily as a last step before adding color or inking lines. It's also important to keep the refined sketch drawn lightly in pencil so you can work color in on top of your pencil sketch.

Return to your refined sketch after a day or two to make sure you are looking at it with a fresh eye. This way you can add and catch things you might have missed.

FINALIZING / COLOR

Finalizing is the step after finishing your revised sketch. This is the stage where you add ink and color, and you can either do so over your revised sketch, or you may choose to redraw your revised sketch. If you prefer to finalize your illustration without pencil lines, you can redraw a much lighter version of the revised sketch, and ink on top of that.

You will need to determine the tools you plan to use for your final project and the color palette. If you are having trouble selecting appropriate colors, refer to your inspiration images—and remember that you may want to work with a limited palette. If jumping into color still doesn't feel right, start with neutral colors, like greys or tans to assign tonal values to your illustration. For example, a darker grey for a darker blue and a lighter grey for a yellow. Or using a black pen, draw only outlines—and then sleep on it before adding color.

FINAL !

At this point, your illustration should be final, but take another look at your work. It never hurts to do a second pass. If everything is looking great, now you can take pictures, share it, or send it off to the client!

ILLUSTRATION 102:
completing your illustration digitally

It's helpful to create your illustrations in this workbook so you can track your progress through each step. But you may want the opportunity to complete some illustrations on the computer or take a completed illustration and make small edits on the computer. The benefit of finalizing digitally, rather than creating the final illustration on paper, is the ability to make edits more easily. You can change color with the click of a button, erase without leaving a trace, and if you make a mistake you can just undo it. Just be sure to save early and often. However, even with the advancements in software and access to more realistic brushes, there are some things you can't replicate on the computer. Plus, creating illustrations on paper will help improve your drawing skills, because you need to be more thoughtful with each stroke.

Following are the basics of taking your illustration from refined sketch to final outside of this workbook, using either vector-based illustration software or Adobe Photoshop. Or, if you've created a final piece in the workbook and want to bring it in the computer, follow the tips mentioned here to take your final drawing from paper to digital.

| **PHOTOSHOP** If you prefer to work in Photoshop to create your final illustration, you can scan in your selected sketch and draw over it using a tablet, or simply use it as reference. When working in Photoshop with a graphics tablet, remember to work in layers. That way you can easily make small revisions or move the art around as necessary. At this stage, try to keep the colors as neutral as possible to avoid getting distracted with making color decisions—you can approach color from a fresh perspective when the piece is finalized. Adding texture can also help create depth and character in your illustration. Experiment with scanning in textures and using Photoshop brushes, and remember that you want the texture to highlight your illustration, not disguise it.

You can also use Photoshop to add color to your inked drawing. Once you scan in your drawing and bring the file into Photoshop, you may want to adjust the levels to remove the paper background, so the drawing is relatively black and white. You will lose some texture, but you can always add texture back in later. To add color just like you would in a coloring book, you need to separate your line drawing from the background. You can do

MAKE a NEW LAYER FOR EVERY SHAPE

that by going into the Channels window and clicking on the selection tool; in the Layers window, create a new layer, and then fill in the selection with the color of your choosing.

If you have finished your piece by hand in the workbook and want to make it digital, first scan in your finished piece. Sometimes bringing a drawing in on the bright, stark computer screen reveals blemishes that on paper look romantic and artsy. Photoshop has several tools to help: Use Levels to up the contrast, Saturation to make the colors more vibrant, and the Clone Stamp tool to remove unwanted lines. Be sure to save your original scan and save new iterations as you work.

VECTOR PROGRAMS

For a more geometric or smooth illustration style, you may consider working in a vector program like Adobe Illustrator. If you are new to Illustrator, begin with the Shapes tool and combine shapes to create images; then move on to the Pen tool to create more dynamic shapes. For each shape and line you create, Illustrator automatically creates a new layer, so you can easily make adjustments as you work. Once you are comfortable with the program, scan or take a picture of your sketch and use that as your guide, breaking down your sketch into separate shapes that you can then layer together to create a composite illustration. Even when working in a vector program, it's still beneficial to work from a sketch so you consider composition, scale, and concept in the early thumbnail and sketch stages. As you are building your illustration, work in neutral colors to avoid becoming distracted with color decisions. Once the illustration is close to final, you can begin assigning color. You can also add drama to your illustration by using gradients very carefully.

THIS ILLUSTRATION IS MADE FROM THESE SHAPES

Artistic License: The freedom of an artist to make creative decisions according to their own liking.

Anthropomorphism: Attributing human traits or characteristics to nonhuman entities.

Brief: Outlines the goals of the assignment, dimensions, and other specific details to consider.

Composition: The arrangement of a layout.

Concept: An idea formed by combining research and approach.

Contour: The profile or outline of a subject/object.

Copywriting: Original text that fits with the concept of the assignment.

Focal Point: The primary place that draws the eye in a composition.

Hatch Marks: Short marks that create depth or an overall texture or pattern.

Imagery: A collection of visuals relating to a concept.

Inking: Creating the final drawing using pen and ink.

Layers: When working in Photoshop, this tool allows you to separate elements.

Mind Map: A way of brainstorming that is organized by relationships, starting with a single word or concept and continually branching out with words that relate to the one preceding it.

Motif: A central theme throughout a body of work that can be referenced through illustration.

Palette: An arrangement of colors chosen to match the tone of the assignment.

Rough/Rough Out: To loosely sketch without scrutinizing style and composition.

Style: Personal artistic approach to illustration.

Tangent: When lines or shapes touch without intersecting or overlapping in an awkward manner.

Thumbnails: Small, rough sketches that capture the desired concept and composition.

Vector: An illustration created in a computer program that creates clean graphics that can be scaled infinitely without losing quality or detail.

WARM UPS

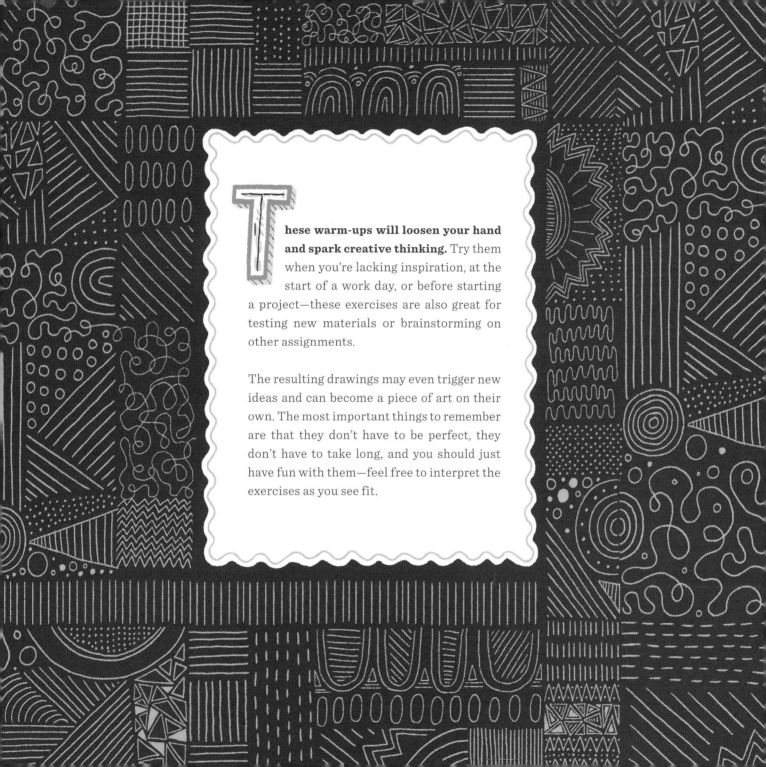

These warm-ups will loosen your hand and spark creative thinking. Try them when you're lacking inspiration, at the start of a work day, or before starting a project—these exercises are also great for testing new materials or brainstorming on other assignments.

The resulting drawings may even trigger new ideas and can become a piece of art on their own. The most important things to remember are that they don't have to be perfect, they don't have to take long, and you should just have fun with them—feel free to interpret the exercises as you see fit.

SCRIBBLE DRAWING

This warm-up is meant to help you see things differently and create something from nothing.

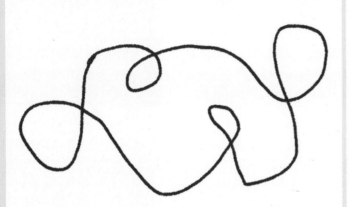

1 Draw a loose scribble without trying to create an image. If you need to loosen up, try not looking at the page.

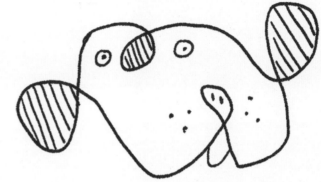

2 Now transform it into something else—it doesn't have to be figurative.

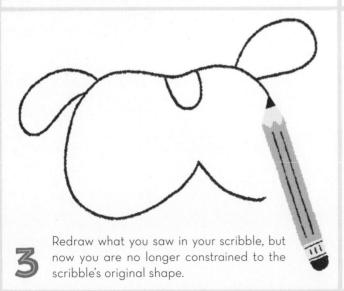

3 Redraw what you saw in your scribble, but now you are no longer constrained to the scribble's original shape.

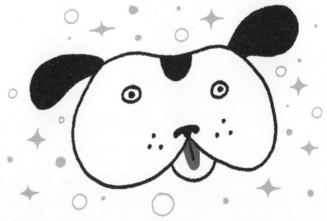

4 Finalize your drawing and compare it to the initial scribble.

Now you try ↓

BLIND CONTOUR

This warm-up is meant to improve your ability to look at shape and form, while challenging you at the same time. Keep your eye on your subject and keep your pencil to the paper the entire time, without lifting it from the page.

1 Choose any subject. Take a mental note of any distinctive features.

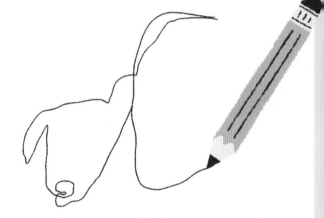

2 Draw what you see while keeping your pencil on the page. Focus on the outline of your subject, and do not look at your drawing yet.

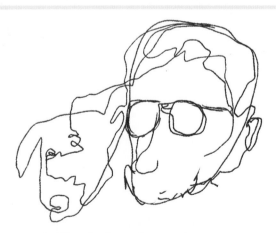

3 Now fill in the form of your subject. Move your eye around the entire subject, and let your pencil follow your eye—but don't look at your page.

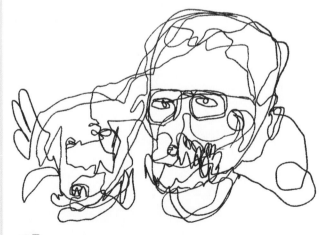

4 It doesn't have to be perfect, just fun!

NO PEEKING!

HATCH MARKS

This warm-up helps you consider how even the simplest marks can create pattern, texture, and depth.

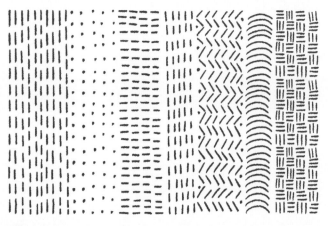

1 Start simple. Make marks, draw rows of straight lines, dots, diagonal lines, or zigzags.

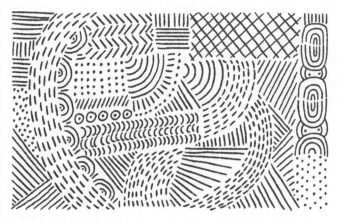

2 Now combine different types of marks to create new patterns.

3 Now use the hatch marks to symbolize dimension.

4 Get creative—use those hatch marks to create letters or plants or animals.

FILL THE PAGE!

SHAPES

This warm-up will let your mind wander into new creative territory and will help you be more flexible when creating illustrations.

1 Start drawing circles, ovals, triangles and rectangles in all different sizes.

2 Now add other shapes to fill the space out. Begin layering the shapes so they start to overlap.

3 Look for patterns, faces, objects, letters, and landscapes in your shapes.

4 Now transform those shapes into what you see: Add color, shading, and details to create faces, landscapes, objects, or letters.

Have fun with it!

REINTERPRET

This warm-up is meant to get your mind limber by prompting you to work with given parameters. This will develop your problem-solving skills and bring more focus to your work.

1 Study the shapes provided to you on the facing page.

2 Redraw the shapes and create a new composition with them.

3 Repeat. Try out several different formations. For each drawing, use only the shapes provided.

4 Create a single composition, a pattern, or as many different illustrations as you can imagine and fill the page.

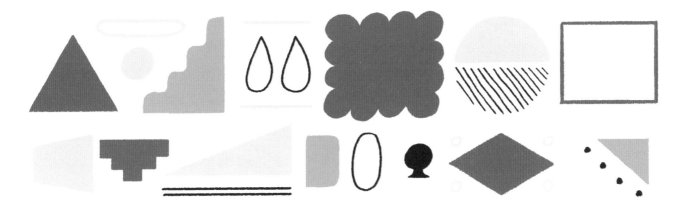

What to draw? Staring at a blank page can be scary, but luckily, you came to the right place! This section of the workbook assigns specific projects that will help you build a portfolio and polish your drawing skills at the same time. Creating illustrations with a practical application shows art directors that you can illustrate for real-world products, and it strengthens your ability to brainstorm and execute a concept as well.

Each assignment opens with an illustration brief like you might receive from an art director, but it also includes guidance, prompting you to consider important details for your illustration. This will help you create stronger concepts. Remember that in these assignments, you're your own client! You can create the illustrations you would like to see in the world, so be sure to have fun and bring your personal taste and style to each assignment.

GREETING CARD

THE BRIEF

For this assignment, your job is to create a greeting card for an occasion of your choosing for your own fictitious greeting card company.

THE CHALLENGE

Think about how color, pattern, or witty copywriting can make your card irresistible and distinctive. There are tons of greeting cards out there, so the biggest challenge here is making a card that feels new.

WHAT TO INCLUDE

- Original illustrations and copywriting for a single greeting card, to include:
 - Card front
 - Inside message and/or spot illustration

SPECIFICATIONS

- Dimensions proportionate to: 5" x 7" or 5" x 5" (12.7 cm x 17.7 cm or 12.7 cm x 12.7 cm)
- Two to three colors

FEELING STUCK?

Here are a few ideas to help you get started:

BONUS Create a boxed set of three card designs. You can even design the box packaging and envelopes!

ART DIRECTION CONSIDERATIONS

What's the occasion?

What is the tone of the greeting card? (Funny, sweet, sentimental?)

Who is your target audience? Who is the card meant to be sent to? Kids, parents, best friends, co-workers?

Text options
• Front:

• Inside:

BRAINSTORM

Make a list or a mind map of as many words and motifs as you can think of that relate to your card's occasion and intended recipient. Checkmark the winners, leave the losers!

To warm up before creating thumbnails, try choosing a word from your text and lettering it in at least three different scripts.

DEVELOP YOUR CONCEPT

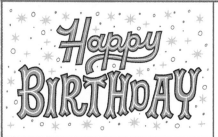

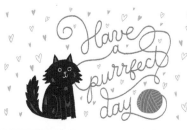

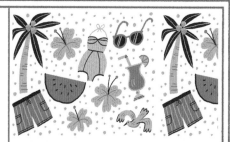

LETTERING

Consider how the style of the lettering will best match the desired tone for your card.

MAKE IT PERSONAL

Give your card a personal touch by including a funny memory, your pet, or even yourself in your illustration.

PATTERN

Consider using an overall pattern of imagery that relates to your concept.

Use this space and the following page to rough out at least eight thumbnails. Be sure to draw your thumbnails in proportion to the dimensions of the final piece, but at a smaller scale. Focus on concept and layout. Limit your time to thirty minutes to avoid getting too caught up in details. You can also test out tools and color palettes here.

MORE THUMBNAILS This loose sketching stage is all about coming up with an idea you'll be excited about and confident to execute, so push yourself to explore as many variations as possible. If you're feeling stumped, sketch a few iterations of your thumbnails from the previous step.

ROUGH SKETCH NO. 1

Pick one of your thumbnails to rough out in greater detail. Sketch lightly so you can make adjustments as you go along, and refer to your brainstorming to make sure you aren't missing important details and ideas. Don't worry about making this sketch perfect, but take notes as you work that point out what you like and what needs adjustment. These notes will be helpful when you create a revised sketch.

ROUGH SKETCH NO. 2

Now choose a different thumbnail to rough out in greater detail. It's important to present at least two options for an illustration assignment. This will help you push yourself to create stronger concepts, and a client will want to see more than one option, too.

Choose one of your sketches to take to final and redraw it here. This is your opportunity to make final edits before jumping into the final with permanent ink.

CHECKLIST

Once you move past this page, decision-making relating to concept and details is over! This handy checklist will help you make absolutely sure that your sketch is ready for the final stage.

1. Have you adhered to the brief while making it your own style?

Check: ⬭

2. Have you explored ALL POSSIBILITIES for CONCEPT, STYLE, and IMAGERY?

check: ⬭

3. Did you take time to LOOK at your sketches with a FRESH EYE?

Check: ⬭

4. Did you CHECK SPELLING? NO STONE UNTURNED?

check: ⬭

5. Have you CHALLENGED yourself?

check: ⬭

6. DO YOU LOVE it?

check: ⬭

7. ARE you SO EXCITED to START you STOPPED READING at #2?

check: ⬭

8. IF YOU answered YES to all questions you are READY to move to FINAL!

FINAL Use this space to create your final illustration. Use your selected materials—ink, colored pencil, whatever you've decided best suits the project—and apply your chosen color palette. Most importantly, have fun with it!

ILLUSTRATED MAP

THE BRIEF

This assignment is to illustrate a map of a destination of your choosing. The map will be published as a postcard, so it should be clear at a small scale. Think creatively about what kind of map you want to make. Maps can be used for getting around, but they can also give a sense of a place by highlighting pointers and landmarks, or even act as a record of events. They can be densely packed with illustration or simple and subtle. Your job is to create a map that captures a portrait, in some way, of the place it represents.

THE CHALLENGE

The biggest challenge will be deciding how to organize all the pertinent information on the map, so that it's both clear and appealing as an editorial illustration.

WHAT TO INCLUDE

- Original illustration for a postcard-size illustrated map, to include:
 - Compass
 - Legend
 - At least three different landmarks

SPECIFICATIONS

Dimensions proportionate to: 5" x 7"
(12.7 cm x 17.7 cm)

FEELING STUCK?

Here are a few ideas to help you get started:

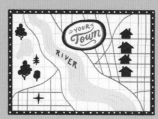

BONUS Create an illustrated travel guide that calls out particular attractions in greater detail.

ART DIRECTION CONSIDERATIONS

What's the destination?

What is it best known for?

How would you describe your destination? (Historic, quiet, bustling, dreamy?)

Who is your target audience? (Tourists, cyclists, families?)

What inspiration and reference material will you gather?

BRAINSTORM

Make a list or a mind map of as many words and motifs as you can think of that relate to the destination of your choosing. Checkmark the winners, leave the losers!

DEVELOP YOUR CONCEPT

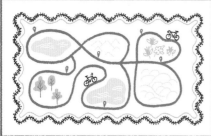

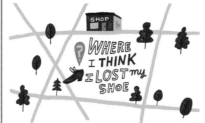

BORDERS

Borders are not only decorative but can also support your concept. For example, if your map is of local bike paths, perhaps the border looks like bike tracks.

MAKE IT PERSONAL

Try giving your map a personal touch by inserting a funny memory or a personal association you have with the place.

LEGEND

Create a legend to help guide your reader around the map with illustrated icons.

Use this space and the following page to rough out at least eight thumbnails. Be sure to draw your thumbnails in proportion to the dimensions of the final piece, but at a smaller scale. Focus on concept and layout. Limit your time to thirty minutes to avoid getting too caught up in details. You can also test out tools and color palettes here.

MORE THUMBNAILS This loose sketching stage is all about coming up with an idea you'll be excited about and confident to execute, so push yourself to explore as many variations as possible. If you're feeling stumped, sketch a few iterations of your thumbnails from the previous step.

ROUGH SKETCH NO. 1

Pick one of your thumbnails to rough out in greater detail. Sketch lightly so you can make adjustments as you go along, and refer to your brainstorming to make sure you aren't missing important details and ideas. Don't worry about making this sketch perfect, but take notes as you work that point out what you like and what needs adjustment. These notes will be helpful when you create a revised sketch.

ROUGH SKETCH NO. 2 Now choose a different thumbnail to rough out in greater detail. It's important to present at least two options for an illustration assignment. This will help you push yourself to create stronger concepts, and a client will want to see more than one option, too.

 REVISED SKETCH Choose one of your sketches to take to final and redraw it here. This is your opportunity to make final edits before jumping into the final with permanent ink. You can also test out tools and establish a color palette to use for your final illustration in the space here.

CHECKLIST

Once you move past this page, decision-making relating to concept and details is over! This handy checklist will help you make absolutely sure that your sketch is ready for the final stage.

1. Have you adhered to the brief while making it your own style?
check: ⬭

2. Have you explored ALL POSSIBILITIES for CONCEPT, STYLE, and IMAGERY?
check: ⬭

3. Did you take time to LOOK at your sketches with a FRESH EYE?
Check: ⬭

4. Did you CHECK SPELLING? NO STONE UNTURNED?
check: ⬭

5. Have you CHALLENGED yourself?
check: ⬭

6. DO YOU LOVE it?
check: ⬭

7. ARE you SO EXCITED to START you STOPPED READING at #2?
check: ⬭

8. IF YOU answered YES to all questions you are READY to move to ⇛FINAL!⇚

FINAL Use this space to create your final illustration. Use your selected materials—ink, colored pencil, whatever you've decided best suits the project—and apply your chosen color palette. Most importantly, have fun with it!

BOOK COVER

THE BRIEF

This assignment is to create an illustration for the cover of a book of your choosing. Book covers should have an eye-catching illustration that speaks to the book's content, a legible title, and the author's name.

THE CHALLENGE

The biggest challenge is capturing the essence of the book while keeping it simple and eye-catching. Choose a book that you are familiar with, and you'll be able to pull more unique defining moments from the book rather than the more obvious parts. Find a common thread from the book that could be the key to your unique book cover concept.

FEELING STUCK?

Here are a few ideas to help you get started:

WHAT TO INCLUDE

- Original illustrations for a book cover, to include:
 - Title
 - Author's name

SPECIFICATIONS

Dimensions proportionate to: 5" x 7" (12.7 cm x 17.7 cm)

BONUS Create a set of three book covers that work together as a series.

ART DIRECTION CONSIDERATIONS

What is the book's title?

What is the book's genre?

Who is the main character?

How does the book make you feel?

Who is the book's primary audience? (Kids, teens, design-minded people, creative people?)

BRAINSTORM

Make a list or a mind map of as many motifs as you can think of from the book to include in your illustration. Checkmark the winners, leave the losers!

VISUAL BRAINSTORM

To jump-start your sketching, choose an important object or character in the book and draw it in two different styles.

DEVELOP YOUR CONCEPT

LETTERING	SUBTLETY	ABSTRACT
1984	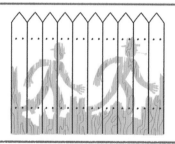	
For a simple yet impactful approach to your cover, make the lettering the main focal point of the cover, and shape your illustrations around it.	Use a subtle nod to the plot and characters. In this example for *Tom Sawyer*, I've illustrated the characters in silhouette on a partially painted fence.	Consider creating an abstract illustration to tie in to the concept. For example, a mystery novel could have layers of shadows that create an abstract design.

THUMBNAILS Use this space and the following page to rough out at least eight thumbnails. Be sure to draw your thumbnails in proportion to the dimensions of the final piece, but at a smaller scale. Focus on concept and layout. Limit your time to thirty minutes to avoid getting too caught up in details. You can also test out tools and color palettes here.

MORE THUMBNAILS

This loose sketching stage is all about coming up with an idea you'll be excited about and confident to execute, so push yourself to explore as many variations as possible. If you're feeling stumped, sketch a few iterations of your thumbnails from the previous step.

ROUGH SKETCH NO. 1

Pick one of your thumbnails to rough out in greater detail. Sketch lightly so you can make adjustments as you go along, and refer to your brainstorming to make sure you aren't missing important details and ideas. Don't worry about making this sketch perfect, but take notes as you work that point out what you like and what needs adjustment. These notes will be helpful when you create a revised sketch.

ROUGH SKETCH NO. 2 Now choose a different thumbnail to rough out in greater detail. It's important to present at least two options for an illustration assignment. This will help you push yourself to create stronger concepts, and a client will want to see more than one option, too.

REVISED SKETCH Choose one of your sketches to take to final and redraw it here. This is your opportunity to make final edits before jumping into the final with permanent ink. You can also test out tools and establish a color palette to use for your final illustration in the space here. If you feel nervous about adding final color, try a warm-up and use the materials you plan to use for your final.

CHECKLIST

Once you move past this page, decision-making relating to concept and details is over! This handy checklist will help you make absolutely sure that your sketch is ready for the final stage.

1. Have you adhered to the brief while making it your own style?

check: ⬭

2. Have you explored ALL POSSIBILITIES for CONCEPT, STYLE, and IMAGERY?

check: ⬭

3. Did you take time to LOOK at your sketches with a FRESH EYE?

Check: ⬭

4. Did you CHECK SPELLING? NO STONE UNTURNED?

check: ⬭

5. Have you CHALLENGED yourself?

check: ⬭

6. DO YOU LOVE it?

check: ⬭

7. ARE you SO EXCITED to START you STOPPED READING at #2?

check: ⬭

8. IF YOU answered YES to all questions you are READY to move to ⇒FINAL!⇐

FINAL Use this space to create your final illustration. Use your selected materials—ink, colored pencil, whatever you've decided best suits the project—and apply your chosen color palette. Most importantly, have fun with it!

EDITORIAL

THE BRIEF

This assignment is to create an illustration that will be paired with an article listing recommended reading for the summer or winter for a travel magazine. You may choose which season you'd like to illustrate, or do both! This is a spot illustration, so keep it simple, without too many small details. This illustration should not have lettering, so make sure your concept is clear, without having to spell anything out. And be sure your illustration is immediately recognizable as summer or winter.

THE CHALLENGE

The biggest challenge in editorial assignments is coming up with a smart concept that can be illustrated simply and easily understood. It's a tall order for a small illustration. Research and brainstorming will be very important for this assignment, because the key to a successful editorial illustration is making connections that relate to the concept and depicting them visually.

WHAT TO INCLUDE

Original spot illustration about summer/winter reading

SPECIFICATIONS

Dimensions proportionate to: 5" x 5" (12.7 cm x 12.7 cm)
Two to three colors

FEELING STUCK?

Here are a few ideas to help you get started:

 BONUS Create three small icons to use as spot illustrations that correspond with the theme of the article.

Summer reading or winter reading?

What books are recommended? List titles here:

Who is the audience for the magazine, and for the article? (Kids, bibliophiles, tourists?)

What inspiration and reference material will you gather?

BRAINSTORM

Make a list or a mind map of as many words and motifs as you can think of that relate to summer or winter and reading. Checkmark the winners, leave the losers! Pair words together to create concepts.

Draw two concepts in two different ways, using your lists on the previous page.

DEVELOP YOUR CONCEPT

LIMITED COLOR

The brief calls for a limited color palette, so play with using the background as another color.

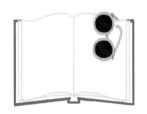

SIMPLIFIED FORMS

Use the most recognizable form when illustrating. For example, if you show only the spine of a book it may read as a rectangle, not immediately as a book.

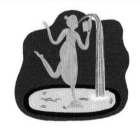

VISUAL CONNECTIONS

Try combining seemingly disparate ideas to create one clever concept. In this example, I thought a sculptural fountain of a woman reading felt summery.

Use this space and the following page to rough out at least eight thumbnails. Be sure to draw your thumbnails in proportion to the dimensions of the final piece, but at a smaller scale. Focus on concept and layout. Limit your time to thirty minutes to avoid getting too caught up in details. You can also test out tools and color palettes here.

MORE THUMBNAILS This loose sketching stage is all about coming up with an idea you'll be excited about and confident to execute, so push yourself to explore as many variations as possible. If you're feeling stumped, sketch a few iterations of your thumbnails from the previous step.

ROUGH SKETCH NO. 1

Pick one of your thumbnails to rough out in greater detail. Sketch lightly so you can make adjustments as you go along, and refer to your brainstorming to make sure you aren't missing important details and ideas. Don't worry about making this sketch perfect, but take notes as you work that point out what you like and what needs adjustment. These notes will be helpful when you create a revised sketch.

ROUGH SKETCH NO. 2 Now choose a different thumbnail to rough out in greater detail. It's important to present at least two options for an illustration assignment. This will help you push yourself to create stronger concepts, and a client will want to see more than one option, too.

REVISED SKETCH

Choose one of your sketches to take to final and redraw it here. This is your opportunity to make final edits before jumping into the final with permanent ink.

CHECKLIST

Once you move past this page, decision-making relating to concept and details is over! This handy checklist will help you make absolutely sure that your sketch is ready for the final stage.

1. Have you adhered to the brief while making it your own style?

check: ⬜

2. Have you explored ALL POSSIBILITIES for CONCEPT, STYLE, and IMAGERY?

check: ⬜

3. Did you take time to LOOK at your sketches with a FRESH EYE?

Check: ⬜

4. Did you CHECK SPELLING? NO STONE UNTURNED?

check: ⬜

5. Have you CHALLENGED yourself?

check: ⬜

6. DO YOU LOVE it?

check: ⬜

7. ARE you SO EXCITED to START you STOPPED READING at #2?

check: ⬜

8. IF YOU answered YES to all questions you are READY to move to ⇒FINAL!⇐

Use this space to create your final illustration. Use your selected materials—ink, colored pencil, whatever you've decided best suits the project—and apply your chosen color palette. Most importantly, have fun with it!

BOTTLE PACKAGING

THE BRIEF

This assignment is to create a label for a bottle for your own fictitious drink company. Come up with the name, flavor of the drink, and a company name. Consider what catches your eye when you are shopping for a drink.

THE CHALLENGE

The challenge is to create a label that is both distinctive and works at a small scale. Focus on creating a concept that relates to the flavor or name of the drink. Include your own copywriting. You also want to be sure that the illustration is appropriate for the scale of the bottle; include too many small details, and you may begin to confuse your key concept. Think about the shape of the bottle as you create thumbnails.

WHAT TO INCLUDE

> Original illustration for bottle label design, to include:
> - Name of flavor/drink
> - Name of company

SPECIFICATIONS

> Dimensions proportionate to: 3" x 5" (7.62 cm x 12.7 cm)
> Three to four colors

FEELING STUCK?

Here are a few ideas to help you get started:

 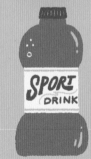

BONUS

Design packaging for a bottle carrier. Use the same style you created for the design of the bottle, and reinterpret the design for the different scale and application.

ART DIRECTION CONSIDERATIONS

What's in the bottle? _____

What's the name of your drink company? Ideas:

What is the tone of your brand? (Funny, sophisticated?)

Who is your brand's target audience?
(Health nuts, artisanal enthusiasts, partygoers?)

BRAINSTORM

List or make a mind map of as many motifs as you can think of that relate to your branding. You can also use this space to generate a list of potential brand names. Checkmark the winners, leave the losers!

Draw what shape you want your bottle to be. Will it be a classic soda bottle shape? A can? Or something brand new?

DEVELOP YOUR CONCEPT

SYMMETRY

Symmetry can help give your design an impactful but simple layout, especially when working within size limitations.

CREATE A LOGO

Create a logo for your drink company. This may also help inform the style of the label.

LEGAL COPY

Consider how the secondary information (i.e., legal copy, volume, ingredients) will work in your design and concept.

Use this space and the following page to rough out at least eight thumbnails. Be sure to draw your thumbnails in proportion to the dimensions of the final piece, but at a smaller scale. Focus on concept and layout, and for this assignment also consider the shape of the bottle in your thumbnails. Limit your time to thirty minutes to avoid getting too caught up in details. You can also test out tools and color palettes here.

MORE THUMBNAILS

This loose sketching stage is all about coming up with an idea that you'll be excited about and confident to execute, so push yourself to explore as many variations as possible. If you're feeling stumped, sketch out different iterations of your thumbnails from the previous step.

ROUGH SKETCH NO. 1

Now, focusing on the label shape only, pick one of your thumbnails to rough out in greater detail. Sketch lightly so you can make adjustments as you go along, and refer to your brainstorming to make sure you aren't missing important details and ideas. Don't worry about making this sketch perfect, but take notes as you work that point out what you like and what needs adjustment. These notes will be helpful when you create a revised sketch.

ROUGH SKETCH NO. 2 Now choose a different thumbnail to rough out in greater detail. It's important to present at least two options for an illustration assignment. This will help you push yourself to create stronger concepts, and a client will want to see more than one option, too.

REVISED SKETCH

Choose one of your sketches to take to final and redraw it here. This is your opportunity to make final edits before jumping into the final with permanent ink.

CHECKLIST

Once you move past this page, decision-making relating to concept and details is over! This handy checklist will help you make absolutely sure that your sketch is ready for the final stage.

1. Have you adhered to the brief while making it your own style?
check: ◯

2. Have you explored ALL POSSIBILITIES for CONCEPT, STYLE, and IMAGERY?
check: ◯

3. Did you take time to LOOK at your sketches with a FRESH EYE?
Check: ◯

4. Did you CHECK SPELLING? NO STONE UNTURNED?
check: ◯

5. Have you CHALLENGED yourself?
check: ◯

6. DO YOU LOVE it?
check: ◯

7. ARE you SO EXCITED to START you STOPPED READING at #2?
check: ◯

8. IF YOU answered YES to all questions you are READY to move to ⇒FINAL!⇐

FINAL Use this space to create your final illustration. Use your selected materials—ink, colored pencil, whatever you've decided best suits the project—and apply your chosen color palette. Most importantly, have fun with it!

CEREAL BOX

THE BRIEF

For this assignment, create packaging for a fictitious cereal brand of your imagining by illustrating a travel-size cereal box. You are responsible for all the copywriting, lettering, and illustration.

THE CHALLENGE

Your biggest challenge is to create a layout that feels distinctive and fresh. You can look at vintage cereal boxes for inspiration, but be sure to look at a variety of packaging to inspire a new look for your box. Understanding your target audience will be imperative to finding the right direction for your design.

WHAT TO INCLUDE

- Original illustrations for the front of a travel-sized cereal box, to include:
 - Name of cereal
 - Flavor

SPECIFICATIONS

Dimensions proportionate to: 3" x 4" (7.6 cm x 10.16 cm)
Two to four colors

FEELING STUCK?

Here are a few ideas to help you get started:

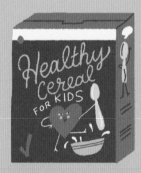

BONUS

Design the back of the cereal box. Is there a game? Health information? Another full illustration?

ART DIRECTION CONSIDERATIONS

What are the cereal ingredients?

What makes this cereal special?

Cereal brand name options:

Who is the target audience for this cereal? (Kids, health enthusiasts, on-the-go professionals?)

What inspiration and reference material will you gather?

BRAINSTORM

Make a list or a mind map of as many words and motifs as you can think of that relate to your cereal. You can also use this space to brainstorm brand names. Checkmark the winners, leave the losers!

To get in the mindset of illustrating for a cereal box, draw your favorite cereal.

DEVELOP YOUR CONCEPT

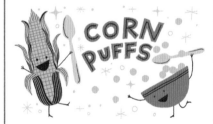

SIMPLICITY

Sometimes taking away, rather than adding on, helps create a better design.

ANTHROPOMORPHISM

Giving inanimate objects a personality can liven up your illustration and generate a positive response in your viewer.

LETTERING

Create custom lettering to establish a signature look for your cereal brand.

THUMBNAILS Use this space and the following page to rough out at least eight thumbnails. Be sure to draw your thumbnails in proportion to the dimensions of the final piece, but at a smaller scale. Focus on concept and layout. Limit your time to thirty minutes to avoid getting too caught up in details. You can also test out tools and color palettes here.

MORE THUMBNAILS

This loose sketching stage is all about coming up with an idea you'll be excited about and confident to execute, so push yourself to explore as many variations as possible. If you're feeling stumped, sketch a few iterations of your thumbnails from the previous step.

ROUGH SKETCH NO. 1 Pick one of your thumbnails to rough out in greater detail. Sketch lightly so you can make adjustments as you go along, and refer to your brainstorming to make sure you aren't missing important details and ideas. Don't worry about making this sketch perfect, but take notes as you work that point out what you like and what needs adjustment. These notes will be helpful when you create a revised sketch.

ROUGH SKETCH NO. 2 Now choose a different thumbnail to rough out in greater detail. It's important to present at least two options for an illustration assignment. This will help you push yourself to create stronger concepts, and a client will want to see more than one option, too.

 REVISED SKETCH Choose one of your sketches to take to final and redraw it here. This is your opportunity to make final edits before jumping into the final with permanent ink.

CHECKLIST

Once you move past this page, decision-making relating to concept and details is over! This handy checklist will help you make absolutely sure that your sketch is ready for the final stage.

1. Have you adhered to the brief while making it your own style?

check: ⬭

2. Have you explored ALL POSSIBILITIES for CONCEPT, STYLE, and IMAGERY?

check: ⬭

3. Did you take time to LOOK at your sketches with a FRESH EYE?

check: ⬭

4. Did you CHECK SPELLING? NO STONE UNTURNED?

check: ⬭

5. Have you CHALLENGED yourself?

check: ⬭

6. DO YOU LOVE it?

check: ⬭

7. ARE you SO EXCITED to START you STOPPED READING at #2?

check: ⬭

8. IF YOU answered YES to all questions you are READY to move to FINAL!

FINAL Use this space to create your final illustration. Use your selected materials—ink, colored pencil, whatever you've decided best suits the project—and apply your chosen color palette. Most importantly, have fun with it!

HANDKERCHIEF

THE BRIEF

For this assignment, create an illustration for a handkerchief to be used as a giveaway at an event of your choosing. The handkerchief can be as simple or detailed as you want, but it can only accommodate printing in one or two colors. The event can be anything that interests you: a baby shower, an aromatherapy expo, a fun run, a family reunion, etc.

THE CHALLENGE

This is a fairly open-ended assignment, so the challenge you have is choosing a concept that really helps to promote your chosen event and speaks to its audience. Consider how folks will use the handkerchief and what will be seen when it is folded up—don't ignore the corners, since they are the most visible when folded!

WHAT TO INCLUDE

Original illustrations for handkerchief, to include copywriting

SPECIFICATIONS

Dimensions proportionate to: 8" x 8"
(20.32 cm x 20.32 cm)
One to two colors

FEELING STUCK?

Here are a few ideas to help you get started:

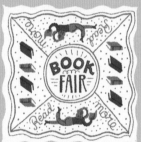
BOOK FAIR

FARMERS' MARKET

TATTOO CONVENTION

WEDDING

BONUS Create a simple bellyband or tag for the packaging of the handkerchief.

What's the event?

Who is going to the event?

What text needs to be included on the handkerchief?
The name of the event, the location, the date, the hosts?

Text options:

BRAINSTORM

List or make a mind map of as many words and motifs as you can think of that relate to the event, where the event takes place, and who the event is for.

For a quick warm-up before getting into sketches, draw your favorite thing about this particular event.

DEVELOP YOUR CONCEPT

PATTERN

Think about how you might fill the entire area of the handkerchief. Try creating a detailed pattern as the backdrop for your text.

SYMMETRY

Symmetry works well on square objects. Use the corners of the handkerchief to create a symmetrical design.

SCALE

You don't have to adhere to the design of a traditional handkerchief. Try playing with scale to create an impactful illustration.

Use this space and the following page to rough out at least eight thumbnails. Be sure to draw your thumbnails in proportion to the dimensions of the final piece, but at a smaller scale. Focus on concept and layout. Limit your time to thirty minutes to avoid getting too caught up in details. You can also test out tools and color palettes here.

MORE THUMBNAILS This loose sketching stage is all about coming up with an idea you'll be excited about and confident to execute, so push yourself to explore as many variations as possible. If you're feeling stumped, sketch a few iterations of your thumbnails from the previous step.

ROUGH SKETCH NO. 1 Pick one of your thumbnails to rough out in greater detail. Sketch lightly so you can make adjustments as you go along, and refer to your brainstorming to make sure you aren't missing important details and ideas. Don't worry about making this sketch perfect, but take notes as you work that point out what you like and what needs adjustment. These notes will be helpful when you create a revised sketch.

ROUGH SKETCH NO. 2 Now choose a different thumbnail to rough out in greater detail. It's important to present at least two options for an illustration assignment. This will help you push yourself to create stronger concepts, and a client will want to see more than one option, too.

REVISED SKETCH Choose one of your sketches to take to final and redraw it here. This is your opportunity to make final edits before jumping into the final with permanent ink.

CHECKLIST

Once you move past this page, decision-making relating to concept and details is over! This handy checklist will help you make absolutely sure that your sketch is ready for the final stage.

1. Have you adhered to the brief while making it your own style?

check: ⬤

2. Have you explored ALL POSSIBILITIES for CONCEPT, STYLE, and IMAGERY?

check: ⬤

3. Did you take time to LOOK at your sketches with a FRESH EYE?

Check: ⬤

4. Did you CHECK SPELLING? NO STONE UNTURNED?

check: ⬤

5. Have you CHALLENGED yourself?

check: ⬤

6. DO YOU LOVE it?

check: ⬤

7. ARE you SO EXCITED to START you STOPPED READING at #2?

check: ⬤

8. IF YOU answered YES to all questions you are READY to move to ⇒FINAL!⇐

Use this space to create your final illustration. Use your selected materials—ink, colored pencil, whatever you've decided best suits the project—and apply your chosen color palette. Most importantly, have fun with it!

ILLUSTRATED POEM *or SHORT STORY*

THE BRIEF

For this assignment, choose a short story or poem and create an illustration that corresponds with the text. This illustration would be featured in a collection of several short stories or poems, so consider how the text would interact with the art. Depending on the length of your chosen piece, you may hand letter the text so it fits with the art or let the illustration live on its own.

THE CHALLENGE

The biggest challenge with this assignment is choosing the right moments of the story or poem to illustrate. The illustration doesn't have to be literal, especially if the writing isn't literal, but it should convey the content while also representing your unique style. Consider how the illustration will be featured with the text. Will the illustration act as a frame for the text, run alongside the text, or live on its own on the page?

WHAT TO INCLUDE

- Original illustration for a short story or poem
- Optional: hand-lettered quote from the text

SPECIFICATIONS

Dimensions proportionate to: 5" x 7"
 (12.7 cm x 17.78 cm)
Two to four colors

FEELING STUCK?

Here are a few ideas to help you get started:

STILL I RISE
MAYA ANGELOU

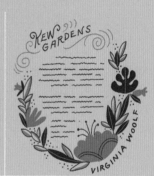
KEW GARDENS
VIRGINIA WOOLF

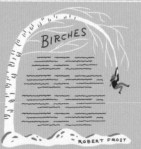
BIRCHES
ROBERT FROST

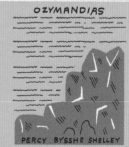
OZYMANDIAS
PERCY BYSSHE SHELLEY

BONUS

Create a panel of two to four illustrations that capture a sequence of events in a narrative for the short story or poem you chose.

ART DIRECTION CONSIDERATIONS

What are a few adjectives that characterize the writing tone and style?

Are there main characters? Who are they? How about key themes?

Who is your target audience? (Writers/poets, collectors, kids?)

What inspiration and reference material will you gather?

BRAINSTORM

Make a list or a mind map of as many words and motifs as you can think of that relate to your chosen poem or short story. Checkmark the winners, leave the losers!

Draw a character or theme two different ways in the space here, and try to weave in a word from your brainstorm.

DEVELOP YOUR CONCEPT

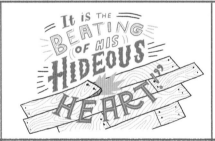

PERSPECTIVE

Use perspective to capture the tone. For example, for a dramatic scene, use an extreme perspective, or, for an intimate moment, try drawing very close-up.

LETTERING

Pull an important line from the text and letter it. Consider how it interacts with the illustrations while keeping it legible.

FRAME

Consider creating an illustration that frames the text for your short story or poem. How will the text be placed within the frame?

Use this space and the following page to rough out at least eight thumbnails. Be sure to draw your thumbnails in proportion to the dimensions of the final piece, but at a smaller scale. Focus on concept and layout thinking about where your illustration will be on the page and how the text will interact. Limit your time to thirty minutes to avoid getting too caught up in details. You can also test out tools and color palettes here.

MORE THUMBNAILS This loose sketching stage is all about coming up with an idea you'll be excited about and confident to execute, so push yourself to explore as many variations as possible. If you're feeling stumped, sketch a few iterations of your thumbnails from the previous step.

Focusing now just on your illustration, rather than the full page layout, pick one of your thumbnails to rough out in greater detail. Sketch lightly so you can make adjustments as you go along, and refer to your brainstorming to make sure you aren't missing important details and ideas. Don't worry about making this sketch perfect, but take notes as you work that point out what you like and what needs adjustment. These notes will be helpful when you create a revised sketch.

ROUGH SKETCH NO. 2 Now choose a different thumbnail to rough out in greater detail. It's important to present at least two options for an illustration assignment. This will help you push yourself to create stronger concepts, and a client will want to see more than one option, too.

 REVISED SKETCH Choose one of your sketches to take to final and redraw it here. This is your opportunity to make final edits before jumping into the final with permanent ink.

CHECKLIST

Once you move past this page, decision-making relating to concept and details is over! This handy checklist will help you make absolutely sure that your sketch is ready for the final stage.

1. Have you adhered to the brief while making it your own style?

check: ⬤

2. Have you explored ALL POSSIBILITIES for CONCEPT, STYLE, and IMAGERY?

check: ⬤

3. Did you take time to LOOK at your sketches with a FRESH EYE?

Check: ⬤

4. Did you CHECK SPELLING? NO STONE UNTURNED?

check: ⬤

5. Have you CHALLENGED yourself?

check: ⬤

6. DO YOU LOVE it?

check: ⬤

7. ARE you SO EXCITED to START you STOPPED READING at #2?

check: ⬤

8. IF YOU answered YES to all questions you are READY to move to ≈FINAL!≈

FINAL Use this space to create your final illustration. Use your selected materials—ink, colored pencil, whatever you've decided best suits the project—and apply your chosen color palette. Most importantly, have fun with it!

PATTERN DESIGN

THE BRIEF

This assignment is to create a pattern for a collection of products: a pillow, a rug, and wallpaper. The pattern should have the same feel throughout the collection, but should also be adapted for each of the three different product applications.

THE CHALLENGE

Consider how the pattern can be used in the same room without feeling too repetitive. You might shift the scale and orientation of your illustration, or reinterpret the color palette differently on each product. To help create three variations of the pattern, think of them as three levels of scale: small, medium, and large.

WHAT TO INCLUDE

One pattern illustration interpreted three ways, to be used as a repeat across three products:
- Pillow
- Area rug
- Wallpaper sheet

SPECIFICATIONS

Three small pattern swatches at least 2" x 2" (5 cm x 5 cm) each
Three to four colors

FEELING STUCK?

Here are a few ideas to help you get started:

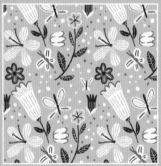

FLORAL

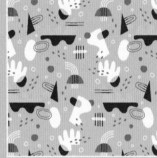

ABSTRACT

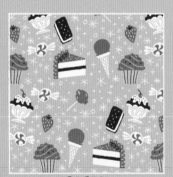

SWEET TREATS

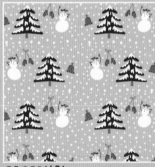

SEASONAL

BONUS

Create branding and packaging for your collection of products!

What are a few adjectives that describe the overall style of your collection? (Modern, bohemian, playful?)

Who is your target audience? (Kids, college students, young professionals?)

Where would your collection be sold?

What inspiration and reference material will you gather?

BRAINSTORM

Make a list or a mind map of as many words and motifs as you can think of that relate to the theme of your pattern. Checkmark the winners, leave the losers!

To loosen up and brainstorm pattern ideas, try arranging found materials into a repeatable design, and draw a pattern based off that still life.

DEVELOP YOUR CONCEPT

HIERARCHY

To create a diverse collection, create three levels of scale in your pattern: small, medium, and large.

CHARACTERS

Create a character to use throughout the series of patterns.

SIMPLICITY

You don't need a lot of details to create a unique pattern. Experiment with scale, angles, and line quality to create a one-of-a-kind pattern.

Use this space and the following page to rough out at least eight thumbnails. Be sure to draw your thumbnails in proportion to the dimensions of the final piece, but at a smaller scale. Focus on concept and layout. Limit your time to thirty minutes to avoid getting too caught up in details. You can also test out tools and color palettes here.

This loose sketching stage is all about coming up with an idea you'll be excited about and confident to execute, so push yourself to explore as many variations as possible. If you're feeling stumped, sketch a few iterations of your thumbnails from the previous step.

ROUGH SKETCH NO. 1

Pick one of your thumbnails to rough out in greater detail. Sketch lightly so you can make adjustments as you go along, and refer to your brainstorming to make sure you aren't missing important details and ideas. Don't worry about making this sketch perfect, but take notes as you work that point out what you like and what needs adjustment. These notes will be helpful when you create a revised sketch.

ROUGH SKETCH NO. 2 Now choose a different thumbnail to rough out in greater detail. It's important to present at least two options for an illustration assignment. This will help you push yourself to create stronger concepts, and a client will want to see more than one option, too.

Choose one of your sketches to take to final and redraw it here. This is your opportunity to make final edits before jumping into the final with permanent ink.

CHECKLIST

Once you move past this page, decision-making relating to concept and details is over! This handy checklist will help you make absolutely sure that your sketch is ready for the final stage.

1. Have you adhered to the brief while making it your own style?
check: ⬤

2. Have you explored ALL POSSIBILITIES for CONCEPT, STYLE, and IMAGERY?
check: ⬤

3. Did you take time to LOOK at your sketches with a FRESH EYE?
Check: ⬤

4. Did you CHECK SPELLING? NO STONE UNTURNED?
check: ⬤

5. Have you CHALLENGED yourself?
check: ⬤

6. DO YOU LOVE it?
check: ⬤

7. ARE you SO EXCITED to START you STOPPED READING at #2?
check: ⬤

8. IF YOU answered YES to all questions you are READY to move to ≫FINAL!≪

Use this space to create your final illustration. Use your selected materials—ink, colored pencil, whatever you've decided best suits the project—and apply your chosen color palette. Most importantly, have fun with it!

TOTE BAG

THE BRIEF

This assignment is to illustrate a tote bag for a store of your choosing. The tote bag can include lettering or illustration or both, but your palette is limited to only two colors, so simplify while keeping your illustration fun.

THE CHALLENGE

Working with only two colors narrows down what you can do with your illustration. You can, however, overlap your two colors to create a third, so consider how you might want to use that third color to add detail and dimension to your illustration.

WHAT TO INCLUDE

Original illustration for a tote bag that may include copywriting

SPECIFICATIONS

Dimensions proportionate to: 6" x 6"
 (15.24 cm x 15.24 cm)
Two colors

FEELING STUCK?

Here are a few ideas to help you get started:

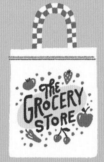 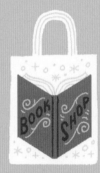

 BONUS Create a tag for the tote bag. Consider how to create branding that matches the tote design.

ART DIRECTION CONSIDERATIONS

What store is your tote bag for?

What is the vibe of the store?

Text options:

Who is your target audience? (Environmentally minded shoppers, bibliophiles, kids?)

What inspiration and reference material will you gather?

BRAINSTORM

Make a list or a mind map of as many words and motifs as you can think of that relate to the store or intended use of the tote. Checkmark the winners, leave the losers!

Most tote bags work best with a bold and simple illustration. To help loosen up your illustrations, pick one word from your brainstorm and draw it in its simplest form.

DEVELOP YOUR CONCEPT

COPYWRITING

A witty phrase or word on a tote bag can add a memorable twist that will call out to your customer.

PATTERN

Use an overall pattern to depict your concept.

HANDLE

Consider incorporating the tote's handle into your concept.

Use this space and the following page to rough out at least eight thumbnails. Be sure to draw your thumbnails in proportion to the dimensions of the final piece, but at a smaller scale. Focus on concept and layout. Limit your time to thirty minutes to avoid getting too caught up in details. You can also test out tools and color palettes here.

MORE THUMBNAILS This loose sketching stage is all about coming up with an idea you'll be excited about and confident to execute, so push yourself to explore as many variations as possible. If you're feeling stumped, sketch a few iterations of your thumbnails from the previous step.

ROUGH SKETCH NO. 1

Pick one of your thumbnails to rough out in greater detail. Sketch lightly so you can make adjustments as you go along, and refer to your brainstorming to make sure you aren't missing important details and ideas. Don't worry about making this sketch perfect, but take notes as you work that point out what you like and what needs adjustment. These notes will be helpful when you create a revised sketch.

ROUGH SKETCH NO. 2

Now choose a different thumbnail to rough out in greater detail. It's important to present at least two options for an illustration assignment. This will help you push yourself to create stronger concepts, and a client will want to see more than one option, too.

REVISED SKETCH

Choose one of your sketches to take to final and redraw it here. This is your opportunity to make final edits before jumping into the final with permanent ink.

CHECKLIST

Once you move past this page, decision-making relating to concept and details is over! This handy checklist will help you make absolutely sure that your sketch is ready for the final stage.

1. Have you adhered to the brief while making it your own style?

check: ⬭

2. Have you explored ALL POSSIBILITIES for CONCEPT, STYLE, and IMAGERY?

check: ⬭

3. Did you take time to LOOK at your sketches with a FRESH EYE?

Check: ⬭

4. Did you CHECK SPELLING? NO STONE UNTURNED?

check: ⬭

5. Have you CHALLENGED yourself?

check: ⬭

6. DO YOU LOVE it?

Check: ⬭

7. ARE you SO EXCITED to START you STOPPED READING at #2?

check: ⬭

8. IF YOU answered YES to all questions you are READY to move to ≥FINAL!≤

FINAL Use this space to create your final illustration. Use your selected materials—ink, colored pencil, whatever you've decided best suits the project—and apply your chosen color palette. Most importantly, have fun with it!

PORTRAIT

THE BRIEF

The assignment is to create a portrait of a famous person or public figure to be featured in a magazine article. You can choose someone in the news, a favorite creative hero, or someone from history.

THE CHALLENGE

The challenge is to capture your chosen figure's personality conceptually, whether you capture their physical likeness or not. Consider other ways to capture a portrait beyond likeness. Are there specific accessories that identify your figure? For example, Julia Child's apron, or Charlie Chaplin's hat and cane? Be creative with your interpretation of what a portrait can be. Gather research on the person of your choosing, and collect a wide variety of reference material for your portrait. Referencing just one photo or image can make it difficult to express your own unique vision of that person, but using multiple sources will help you create a more distinctive approach.

WHAT TO INCLUDE

Original spot illustration to correspond with a magazine article

SPECIFICATIONS

Dimensions proportionate to: 6" x 6" (15.24 cm x 15.24 cm)
Three to four colors

FEELING STUCK?

Here are a few ideas to help you get started:

OPRAH WINFREY

DAVID BOWIE

CARL SAGAN

VIRGINIA WOOLF

BONUS

Create a series of portraits that would be featured in a magazine article of the top five most influential people in a field of your choosing.

Who is your chosen figure?

What are their distinctive features?

What are they famous for?

Who is your target audience?

What kind of magazine is the illustration for?

What inspiration and reference material will you gather?

BRAINSTORM

Make a list or a mind map of as many words and characteristics as you can think of that relate to the person. Checkmark the winners, leave the losers!

Creating a likeness of someone can be daunting. To warm up, draw their most recognizable feature from your brainstorm on the previous page—it could be their hair, attire, eyes, or even shoes.

DEVELOP YOUR CONCEPT

BORDERS

Consider adding a border to help frame your portrait. Include motifs from your figure's physical attributes or accessories that define them as a character.

SIMPLICITY

Simplify the portrait by paring down their features in the most simplistic forms.

REFERENCE

Use a style associated with your figure to create a concept. For example, if your person has retro tattoos, draw the portrait in the style of those tattoos.

Use this space and the following page to rough out at least eight thumbnails. Be sure to draw your thumbnails in proportion to the dimensions of the final piece, but at a smaller scale. Focus on concept and layout. Limit your time to thirty minutes to avoid getting too caught up in details. You can also test out tools and color palettes here.

MORE THUMBNAILS

This loose sketching stage is all about coming up with an idea you'll be excited about and confident to execute, so push yourself to explore as many variations as possible. If you're feeling stumped, sketch a few iterations of your thumbnails from the previous step.

ROUGH SKETCH NO. 1

Pick one of your thumbnails to rough out in greater detail. Sketch lightly so you can make adjustments as you go along, and refer to your brainstorming to make sure you aren't missing important details and ideas. Don't worry about making this sketch perfect, but take notes as you work that point out what you like and what needs adjustment. These notes will be helpful when you create a revised sketch.

ROUGH SKETCH NO. 2 Now choose a different thumbnail to rough out in greater detail. It's important to present at least two options for an illustration assignment. This will help you push yourself to create stronger concepts, and a client will want to see more than one option, too.

Choose one of your sketches to take to final and redraw it here. This is your opportunity to make final edits before jumping into the final with permanent ink.

CHECKLIST

Once you move past this page, decision-making relating to concept and details is over! This handy checklist will help you make absolutely sure that your sketch is ready for the final stage.

1. Have you adhered to the brief while making it your own style?

check: ⬭

2. Have you explored ALL POSSIBILITIES for CONCEPT, STYLE, and IMAGERY?

check: ⬭

3. Did you take time to LOOK at your sketches with a FRESH EYE?

check: ⬭

4. Did you CHECK SPELLING? NO STONE UNTURNED?

check: ⬭

5. Have you CHALLENGED yourself?

check: ⬭

6. DO YOU LOVE it?

check: ⬭

7. ARE you SO EXCITED to START you STOPPED READING at #2?

check: ⬭

8. IF YOU answered YES to all questions you are READY to move to ⮞FINAL!⮜

FINAL Use this space to create your final illustration. Use your selected materials—ink, colored pencil, whatever you've decided best suits the project—and apply your chosen color palette. Most importantly, have fun with it!

JOURNAL

THE BRIEF

The assignment is to create a cover for a journal. Choose a specific niche for your journal—maybe it's travel, cooking, or gardening, or for coffee lovers or cat lovers—and come up with a title and supporting illustrations for the cover that speak to your target audience.

THE CHALLENGE

The challenge here is creating an illustration for the journal that clearly speaks to its intended user. How will this journal be set apart from the many other journals out there? You also want to make sure that the cover doesn't look like a book cover, but a journal that you write in. Having a clear directive for the journal that implies documenting or writing is helpful.

WHAT TO INCLUDE

> Original illustrated journal cover, to include copywriting

SPECIFICATIONS

> Dimensions proportionate to: 5" x 7" (12.7 cm x 17.7 cm)
> Two to four colors

FEELING STUCK?

Here are a few ideas to help you get started:

BONUS To really bring your journal to life, create an interior page design or a "This journal belongs to" page.

ART DIRECTION CONSIDERATIONS

What's the journal theme? _____

Where would your journal be sold? _____

Text options: _____

Who is your target audience? _____

What kind of inspiration and reference material will you gather?_____

BRAINSTORM

Make a list or a mind map of as many words and motifs as you can think of that relate to the theme of your journal. Checkmark the winners, leave the losers!

DEVELOP YOUR CONCEPT ⟩

LETTERING

The cover of a journal should inspire the user to write in it every day. Be sure the lettering style conveys the tone that your intended user would relate to.

COPYWRITING

Clever copywriting, like a play on words, will help attract your target audience. For example, a journal called "Pie-in-the Sky Ideas" will appeal to dessert lovers.

PATTERN

A distinctive, fashionable pattern can give a journal appeal as an accessory to carry around or keep on the desktop.

Use this space and the following page to rough out at least eight thumbnails. Be sure to draw your thumbnails in proportion to the dimensions of the final piece, but at a smaller scale. Focus on concept and layout. Limit your time to thirty minutes to avoid getting too caught up in details. You can also test out tools and color palettes here.

MORE THUMBNAILS This loose sketching stage is all about coming up with an idea you'll be excited about and confident to execute, so push yourself to explore as many variations as possible. If you're feeling stumped, sketch a few iterations of your thumbnails from the previous step.

ROUGH SKETCH NO. 1

Pick one of your thumbnails to rough out in greater detail. Sketch lightly so you can make adjustments as you go along, and refer to your brainstorming to make sure you aren't missing important details and ideas. Don't worry about making this sketch perfect, but take notes as you work that point out what you like and what needs adjustment. These notes will be helpful when you create a revised sketch.

ROUGH SKETCH NO. 2 Now choose a different thumbnail to rough out in greater detail. It's important to present at least two options for an illustration assignment. This will help you push yourself to create stronger concepts, and a client will want to see more than one option, too.

Choose one of your sketches to take to final and redraw it here. This is your opportunity to make final edits before jumping into the final with permanent ink.

CHECKLIST

Once you move past this page, decision-making relating to concept and details is over! This handy checklist will help you make absolutely sure that your sketch is ready for the final stage.

1. Have you adhered to the brief while making it your own style?

check: ◯

2. Have you explored ALL POSSIBILITIES for CONCEPT, STYLE, and IMAGERY?

check: ◯

3. Did you take time to LOOK at your sketches with a FRESH EYE?

check: ◯

4. Did you CHECK SPELLING? NO STONE UNTURNED?

check: ◯

5. Have you CHALLENGED yourself?

check: ◯

6. DO YOU LOVE it?

check: ◯

7. ARE you SO EXCITED to START you STOPPED READING at #2?

check: ◯

8. IF YOU answered YES to all questions you are READY to move to ⇒FINAL!⇐

FINAL Use this space to create your final illustration. Use your selected materials—ink, colored pencil, whatever you've decided best suits the project—and apply your chosen color palette. Most importantly, have fun with it!

PRACTICE SHEETS

The best way to get better at drawing is by drawing, so this section is devoted to practice. The more you practice, the more adept you'll become at taking on any kind of illustration project. Follow the prompts—and have fun with it! If you feel stumped on how something should look, check out the sidebars for guidance and inspiration. The practice sheets are great for downtime between projects, or just for boosting your confidence.

BIKES

Drawing a bicycle is a great way to practice drawing machinery, because it's a simple form and there are many styles to choose from. Drawing a person on a bike is slightly trickier, but don't be afraid to use your artistic license. Have fun with color and drawing the scenarios here.

1 DRAW YOUR DREAM BICYCLE

2 DRAW A TRICYCLE

3 DRAW A COUPLE ON A TANDEM BIKE

4 DRAW A PERSON WEARING A GORILLA SUIT
RIDING A BIKE

INSPIRATION TO HELP
YOU GET STARTED

BIKE WITH LIGHT

TRICYCLE

TANDEM BIKE

DON'T FORGET A HELMET!

ANIMALS

You can get away with abstracting and stylizing animals quite a bit because of their distinctive features—and it's great practice for depicting something simple and recognizable in your own style. Have fun drawing the scenarios here.

1 DRAW A CAT

2 DRAW A DOG

3 DRAW THE DOG AND CAT HANGING OUT TOGETHER

4 DRAW A PIG RIDING A HORSE

INSPIRATION TO HELP
YOU GET STARTED

'FRAIDY CAT

HAPPY TURTLE

SPOTTED PIG

GOOD DOG

HAND LETTERING

Lettering is the art of drawing words. To practice, try drawing a single word multiple ways. Plan your word out by loosely writing it first, and then add weight to the letters. Use the prompts below as inspiration for different ways to draw your chosen word. Have fun and play with the lettering styles shown in the sidebar.

1 SIMPLE

2 FANCY

3 PLAYFUL

4 ENERGETIC

5 SPOOKY

6 FLORAL

SERIF

ORNATE

SANS SERIF

SCRIPT

GOLD

REPRESENTATIONAL

HANDS

No body part is as challenging to draw as hands. If drawn too simple it can look unfinished; too realistic, and it may look disconnected from your illustration. Try drawing hands in a variety of styles: hands with noodle-y fingers, broad and geometric, or simple. Don't forget to add a watch or a ring here and there.

1 DRAW A HAND

2 DRAW A HAND HOLDING A TEA CUP

3 DRAW A HAND SHAKING ANOTHER HAND

4 DRAW TWO HANDS EXCHANGING GIFTS

COLOR

It's important to consider how the mood of an illustration is affected by color. The color palettes you create in this exercise just may come in handy in assignments down the road. Create a color palette that best captures the mood for each of the prompts here.

1 COLD

2 HOT

3 MYSTERIOUS

4 FUN

5 ROMANTIC

6 CALM

RETRO

SERENE

EARTHY

PLAYFUL

TREES

When drawing trees, don't feel as though you have to draw each individual leaf. Instead, think of how you can play with texture and silhouette to represent the tree. Draw the trees in their most simplistic form or create abstract silhouettes—and have fun with it!

1 DRAW A TREE

2 DRAW A TREE IN THE WIND

3 DRAW TWO TREES HOLDING A HAMMOCK

4 DRAW AUTUMN TREES

ARCHITECTURE

The intricacy of architecture can be intimidating, but if you focus on creating a basic shape for the structure, it's fun to add in the details. Consider how you can simplify while capturing the key elements of the building.

1 DRAW A BEACH HOUSE

2 DRAW A BRIDGE

3 DRAW A CASTLE

4 DRAW A SKYSCRAPER

INSPIRATION TO HELP
YOU GET STARTED

ABSTRACT BRICK

QUAINT WINDOW

WONKY ROOF SHINGLES

ABSTRACT PERSPECTIVE

PEOPLE

Drawing people can be challenging. Remember, you don't have to draw realistically. Have fun with your characters, and add accessories, such as glasses, fun hair, and crazy outfits.

1 DRAW A PERSON

2 DRAW A PERSON RUNNING

3 DRAW A PERSON RELAXING

4 DRAW TWO PEOPLE ENJOYING A CUP OF TEA

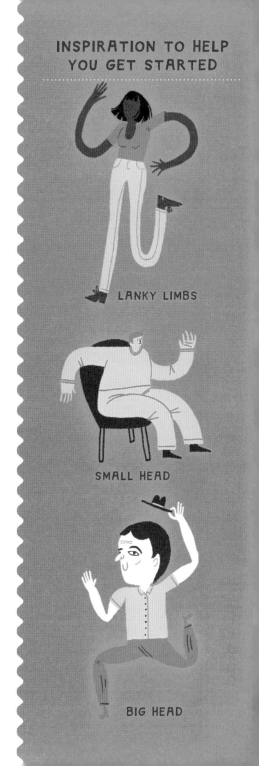

INSPIRATION TO HELP
YOU GET STARTED

LANKY LIMBS

SMALL HEAD

BIG HEAD

LANDSCAPES

Creating a landscape or environment can set the tone for an illustration. In the prompts here, consider how to simplify and abstract the landscapes so other illustrations in the foreground can stand out, and how you can use pattern and texture to help define variations in the landscape.

1 DRAW A VALLEY

2 DRAW A PARK

3 DRAW A FOREST

4 DRAW A STORMY BEACH

INSPIRATION TO HELP YOU GET STARTED

MEADOW PATTERN

SIMPLE HILL

SHAPELY VALLEY

REALISTIC MOUNTAINS

FLOWERS

Flowers are one of my favorite things to draw because they are easily simplified into basic shapes, so the focus is on color and pattern. Play with scale, color, and pattern to represent the types of flowers listed here.

1 DRAW A DAISY

2 DRAW A ROSE

3 DRAW A CROWN OF FLOWERS

4 DRAW A BOUQUET

GEOMETRIC FLOWER

FLORAL BORDER

RETRO FLOWER

SIMPLE BOUQUET

This section is designed to take you out of your comfort zone and prompt you to try new things. It can refresh your perspective and guide you to find new methods to incorporate in your work. Turn to these pages whenever you need a jolt to liven up your illustrations!

YES YOU CAN!

Everyone has something they believe they can't draw or is just tricky to draw. The key is finding a way to draw that thing that suits you and your style best. If your first drawing doesn't turn out as you hoped, just keep trying!

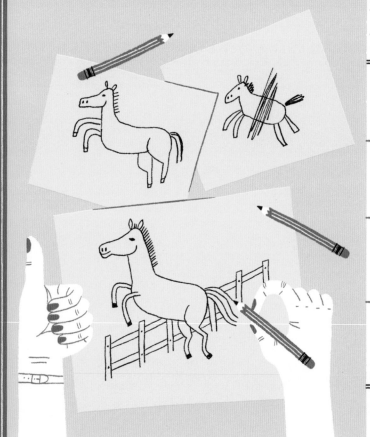

Basic RULES

WHAT:	SOMETHING you THINK you CAN'T DRAW
WHEN:	WHY NOT TODAY?
WHERE:	ANYWHERE
TIME LIMIT:	1 HOUR

A	Think of something you believe you can't draw.
B	Look at references, study it, and find parts of it that inspire you.
C	Start simple.
D	Draw and redraw.

What DID you LEARN from this CHALLENGE?

SEE! YOU CAN DRAW THAT.

UP & AT 'EM

Let's see how you draw first thing in the morning. Capture those groggy, half-awake, half-asleep moments before getting out of bed and before coffee. In these early hours of the day, you aren't as inclined to overthink things, so your drawings will have a more genuine feel.

morning!

Basic RULES

WHAT: DRAW FIRST THING in the MORNING

WHEN: AS SOON AS YOU WAKE UP

WHERE: BED

TIME LIMIT: 15 MINUTES

 A — Plan the night before you try this challenge, so you have the book and a pencil ready at your bedside.

 B — Wake up and, before reaching for your phone to check e-mails, draw!

 C — Draw your dream or the first thing you see. Don't make revisions, just let the drawing flow.

 D — After coffee, observe your drawing.

What DID you LEARN from this CHALLENGE?

YOU CAN SLEEP IN TOMORROW.

DRAWING OUTSIDE

Draw outside, and let the world inspire what you draw next. The challenge of drawing outside is being exposed to the elements and other distractions. The goal is to let your surroundings influence you, rather than shutting them out.

Basic RULES

WHAT: DRAW OUTSIDE
WHEN: A FREE AFTERNOON
WHERE: OUTSIDE
TIME LIMIT: 1 HOUR

A — Carve out an afternoon that you can spend at a park or place of inspiration outdoors.

B — Observe your surroundings and draw whatever catches your eye.

C — Listen—jot down things you overhear and let them inspire you.

D — Don't limit yourself. Fill the page as you document your surroundings.

What DID you LEARN from this CHALLENGE?

NOW GO BACK TO DRAWING IN SECLUSION.

DRAWING WITH LIGHT

This exercise focuses on light and shadow. Choose a subject lit only by moonlight, streetlamps, or, if you're indoors, a flashlight. The goal is to capture highlights only, so you'll draw with light instead of dark.

Basic RULES

WHAT: DRAW WITH LIGHT

WHEN: ANYTIME

WHERE: INSIDE OR OUTSIDE

TIME LIMIT: 45 MINUTES

A Find a subject lit by moonlight or a streetlamp. If you're indoors, shine a light toward your subject.

B Fill your page with pigment—graphite or charcoal works well—so that the entire page is dark.

C Draw only the highlights of your subject by using a white pen or pencil or an eraser. Focus on capturing the way the light falls on the form.

D Emphasize shadows by going back over darker areas to contrast with the highlights.

What DID you LEARN from this CHALLENGE?

NEXT, FOCUS ON THE SHADOWS

NO PEEKING

Drawing from memory allows you to be more creative—unless you have a photographic memory—because it forces you to fill in the blanks using your artistic license. The challenge is to resist looking at references as you draw. Even if you feel stuck at a point in your drawing, push forward. You may unlock something special in your concept or style.

Basic RULES

WHAT: DRAW SOMETHING *from* MEMORY

WHEN: ANYTIME

WHERE: ANYWHERE

TIME LIMIT: 1 HOUR

A	Look for an object or visual reference that inspires you. That will be your subject.
B	When you look at your subject and inspiration material, take note of details, such as texture, tone, and shape. Doing this will leave a stronger impression in your memory.
C	Set aside your reference material and inspiration. Take at least an hour before drawing to let it soak in your memory, and then get to the drawing board.
D	Think about the details that make your subject special and let them drive the drawing.

What DID you LEARN from this CHALLENGE?

NOW IF ONLY YOU COULD REMEMBER
WHERE YOU PUT YOUR KEYS...

A DRAWING A DAY

Drawing daily not only helps you improve your drawing skills, but it also helps you integrate drawing into your everyday routine. The challenge is how to make improvements and develop from one drawing to the next. Try new materials, embrace new styles and colors, and change your perspective on the subject.

10 DAYS of DRAWING

CHECK MARK *the* NUMBERS BELOW *as* YOU COMPLETE *your* DRAWINGS

1	2	3	4	5
6	7	8	9	10

Basic RULES

WHAT: DRAW *the* SAME THING *for* 10 DAYS

WHEN: THE MOST CONVIENIENT TIME EVERY DAY

WHERE: COZY DRAWING SPOT

TIME LIMIT: 30 MINUTES

 A — Identify a subject you'll want to return to day after day.

 B — Challenge yourself each day to make your drawing different from yesterday's: a different color palette, scale, materials, or angle.

 C — These drawings should only take half an hour.

 D — Think about how a different setting, time, and other factors influenced your drawing.

What DID you LEARN from this CHALLENGE?

KEEP UP the
MOMENTUM!
DRAW EVERY DAY!

SWITCH HANDS

Draw with your non-dominant hand. Or, if you are ambidextrous, draw with your foot. While this practice may not be something you incorporate in your daily drawing routine, it's important to get out of your comfort zone.

Basic RULES

WHAT: DRAW WITH your NON-DOMINANT HAND
WHEN: ANYTIME
WHERE: COMFORTABLE DRAWING SPOT
TIME LIMIT: 20 MINUTES

A Start simple with shapes.

B Add on to the shapes with designs, or make them into characters.

C Add color.

D Admire your handiwork! Now, with your dominant hand, how can you build on what you've drawn?

What DID you LEARN from this CHALLENGE?

NOW SWITCH BACK TO YOUR REGULAR DRAWING HAND!

LIGHTNING ROUND

Illustrators are no stranger to working under tight deadlines. Having the ability to work fast will certainly come in handy from time to time. While it's important to meet the deadline, you also want to create a unique illustration. Consider how you can inject style in a short timeframe. In this challenge, set yourself up with a stopwatch and create a drawing based on the prompts here.

Basic RULES

WHAT: 6 QUICK DRAWINGS
WHEN: WHEN YOU HAVE 6 MINUTES TO SPARE
WHERE: COMFORTABLE DRAWING SPOT
TIME LIMIT: 1 MINUTE PER DRAWING

A	Prepare your workspace with a tool you are familiar with—you will use this for all six drawings.
B	Use a timer that will sound an alarm after one minute.
C	Take the first few seconds to consider how you want to draw the prompt. This challenge is one-part first thing that comes to mind, and one-part style and execution.
D	After you finish all six drawings, consider how you can utilize your quick thinking and execution abilities for other assignments.

What DID you LEARN from this CHALLENGE?

1 A WEATHERED SAILBOAT

2 A PROUD GOAT

3 A BRAND NEW CAR

4 A FRENCH CAT

5 A STINKY SANDWICH

6 A NEGLECTED PLANT

OK! NOW YOU CAN BREATHE